GRAVES AND CEMETERIES OF PERTHSHIRE

CHARLOTTE GOLLEDGE

AMBERLEY

*Dedicated to the memory of a beloved and inspirational auntie,
Elizabeth Tarling*

First published 2025

Amberley Publishing
The Hill, Stroud
Gloucestershire, GL5 4EP

www.amberley-books.com

Copyright © Charlotte Golledge, 2025

The right of Charlotte Golledge to be identified as the Author
of this work has been asserted in accordance with the
Copyrights, Designs and Patents Act 1988.

All rights reserved. No part of this book may be reprinted or reproduced
or utilised in any form or by any electronic, mechanical or other means,
now known or hereafter invented, including photocopying and recording,
or in any information storage or retrieval system, without the permission
in writing from the Publishers.

British Library Cataloguing in Publication Data.
A catalogue record for this book is available from the British Library.

ISBN 978 1 3981 2022 8 (print)
ISBN 978 1 3981 2023 5 (ebook)

Typesetting by Hurix Digital, India.
Printed in Great Britain.

Appointed GPSR EU Representative: Easy Access System Europe Oü, 16879218
Address: Mustamäe tee 50, 10621, Tallinn, Estonia
Contact Details: gpsr.requests@easproject.com, +358 40 500 3575

Contents

	Introduction	4
1	Symbolic Scenes and Symbols	6
2	The Picts	25
3	The Covenanters in Perthshire	30
4	The Scottish Episcopal Church in Perthshire	33
5	Clan Burial Grounds	37
6	Preeminent Men	43
7	Notable Women	49
8	Unusual Items and Buildings	55
9	Unusual Burial Grounds	67
10	Forgotten Burial Grounds	70
11	Some of the Best Burial Grounds	75
	Select Bibliography	96

Introduction

All of life is slightly dependent on magic. So is death.

Caroline Kepnes

There is an earthy magic that clings to Perthshire, like lush green ivy on an ancient tree. Tales of fairies are interwoven historically with everyday life. While being far from the coast, it is a region filled with water, from the serene lochs to the awe-inspiring waterfalls. There is a deep atmosphere of mysticism and tranquillity that welcomes visitors and locals alike.

Its burial grounds are no exception to the magic. With funeral art that spans over a thousand years, it evokes deep emotions as it weaves into the tapestry of Perthshire. From the Picts to the Victorians, there is a plethora of examples of mourning unique to their era.

The history of this beautiful region is as vast as its landscape, much of which is shaped by powerful families, including the houses of Murray, Drummond, Menzies, Campbell and Hay. The population of the region has also fluctuated over the centuries. On one side, the effects of the rebellion of 1745 left communities struggling, and the failing, yet once profitable, cottage industries saw many families emigrating. However, with the introduction of mass tourism with the arrival of the railways and Queen Victoria's evident love of Scotland, tourist towns were established at Aberfeldy, Birnam, Crieff and Pitlochry.

Geographically, today Perthshire extends from Strathmore in the east to the pass of Drumochter in the north, Rannoch Moor and Ben Lui in the west and Aberfoyle in the south. The old county extended westward to include Dunblane, Callander, Crianlarich and Tyndrum; however, the boundaries of Perthshire have changed over the last couple of centuries as some areas have been incorporated into other counties and as such some burial grounds may be debated as to their location. Due to some spectacular burial grounds, this book will include historical Perthshire locations.

Perthshire is unique in that it straddles both the Lowlands and the Highlands. Its northern areas are in the more rugged, mountainous terrain, while the south is the flatter, more fertile farmland. Traditionally, the area's religion has also defined its eighteenth- and nineteenth-century burial grounds as the Presbyterian Lowlands meet the Episcopalian Highlands, the contrasting burial markers reflecting the religion practised by the deceased.

Unfortunately, not every burial ground can be covered in this publication as they are so numerous in this region, and some notable ones have been lost to time. As an author, I struggled with the fertile land of history and stories, so rather than travel

geographically, listing them all, I decided to categorise themes and place some notable grounds in the chapters. It does, however, mean that there is always more to explore beyond these pages, and I hope this inspires you to do so.

Kinfauns.

1
Symbolic Scenes and Symbols

Abraham and Isaac

Take now your son, your only son Isaac, whom you love, and go to the land of Moriah, and offer him there as a burnt offering on one of the mountains of which I shall tell you.

<div align="right">Genesis 22</div>

The study of gravestones involves not just looking at the symbols but also understanding the mindset of people at the time, viewing them without modern preconceptions. During the eighteenth century, the effects of the persecution of the Covenanters was still felt. Formerly rejecting the Episcopalian divine right of kings, Presbyterians believed that obedience to God was the very most important part

Abraham and Isaac stone, Grandtully.

of life. The rare Abraham and Isaac stones ultimately give that message, depicting Genesis 22 – Abraham Tested.

The Abraham and Isaac stones at Logierait and Grandtully's St Mary's are clearly recognisable examples. Though there are subtle differences, they highlight the same important scene. At Grandtully, visitors need to enter the small burial ground behind the unassuming chapel. Almost immediately upon entering, the stone is situated to the right of the gate; it is easy to pick out as most of the gravestones surrounding it are of the Victorian era. The carving is of exceptional quality and still very clear. Dated 1784, it is dedicated to local farmer James Thomson and his wife Helen Stuart.

Here, you see Abraham with a knife in one hand and with the other he holds his son down upon the altar he had built. Above the knife, the angel of the Lord stays his hand and reveals the ram to be sacrificed in Isaac's place. The scene is accompanied by the inscription 'Abraham Stayed/Mosscri/ng Isaac/ BY AN ANGEL'.

Adam and Eve

> Now the serpent was more cunning than any beast of the field which the Lord God had made. And he said to the woman, 'Has God indeed said, 'You shall not eat of every tree of the garden?''
>
> Genesis 3

The majority of Adam and Eve stones found in Scotland are more concentrated in Perthshire than any other region. Mainly dating between 1742 and 1785, they are less uniformed than the Abraham and Isaac stones, allowing the stonemason to be more

Adam and Eve stone, Little Dunkeld.

creative and artistic with the scene, especially when depicting the tree. The masons appear to mainly adopt the traditional scene of the naked Adam and Eve standing on either side of the fruit-laden tree while the serpent coils around the trunk, facing Eve. There is little difference between the two figures in most carvings, though Eve sometimes has longer hair and while there is rarely a hint of a bosom, she is given nipples. While the pair are naked in the Garden of Eden, some masons use leaves to cover their nakedness, presumably for modesty.

At Little Dunkeld there are two exceptional examples that stand side by side, carved from harder sandstone that some others carved in the same era. One in particular is so fresh-looking that you would be forgiven for thinking it was a replica stone carved in the last fifty years and not in 1744.

The Cross

Prior to the Reformation a cross would not have been an unusual sight in Lowland Scotland; however, with the Reformed church came reformed practices. Deemed a papist emblem, monuments were no longer allowed to be in the shape of a cross and were very rarely used as symbolic carving. The nineteenth century saw a revival of the cross being used and is often seen adorning the graves of Episcopalians, both simple in design and more intricate, highly decorative Celtic crosses. When walking into a Highland graveyard this is often a way to quickly establish the denomination of the church without looking for an information sign. In the twenty-first century the use of the cross has become more of a personal choice across Scotland.

Holy Trinity churchyard.

Symbols of Mortality

Memento Mori
The symbols of both mortality and immortality were widespread in the seventeenth and eighteenth centuries, especially in the Presbyterian Lowlands. Their popularity began to wane in Perthshire in the nineteenth century and, as such, their meanings have been lost to the majority of today's society.

Death's Head/Death Heid
The Death heid is by far the most commonly used symbol of mortality. The carving of a skull really cannot represent death more clearly. It can be seen in different guises: full face, missing the bottom jaw, gnawing on a bone, front facing, partial profile, in both 3D and 2D, detailed, with simple lines, crossed bones behind or below, crossed sexton tools in place of bones or a rare winged skull.

In case there is any confusion of this ultimate symbol of death, the words 'memento mori' are sometimes added to the carving, which translates to 'remember death', a message to the observer to remind them that they too will die. While this may seem almost threatening to our modern sensibilities, in post-Reformation Scotland it was a

Death's head at Dunblane.

reminder to Presbyterian Scots that they should lead a good and moral life, free from sin, as after death, judgement will come. Unlike the Catholic belief of forgiveness through the Sacrament of Reconciliation, Presbyterians did not believe that any earthly man had the power to forgive in God's name. So, simply put, the message was to live a life that did not need sin to be forgiven.

Death's head is not the only symbol of mortality commonly found. While it may be a solo decoration on a grave marker, it is often accompanied by other symbols to emphasise the message:

Coffin: Single or two crossed. With or without the carrying spokes.
Death Bed Scene: The deceased is lying on their back or side.
Deid Bell/Mort Bell: A handbell or just the bell head. This was the traditional way to give notice of a funeral, and they were also rung during the procession to the grave.

Memento mori.

Death's head with crossed bones, coffin and hourglass at Coupar Angus.

Father Time: The embodied figure represented the passage of time and the finality of earthly life. He is often accompanied by a scythe and an hourglass.

Green Man: A humanoid face with foliage sprouting from the nose, mouth, ears or forehead. From a pagan leaf mask, it was adopted by the Romans in the second century before being used in ecclesiastical buildings in the twelfth century. In Scottish graveyards, it represents the decaying of the old before new life can be created.

Hourglass: The passing of time to the end of one's life. Upright indicates the natural passing and conclusion of life, whereas on its side shows the premature stoppage of life – the sands have been stopped before the complete process. The addition of wings highlights the fleeting nature of life.

King of Terrors: The skeletal personification of Death. He is often holding a weapon, usually a scythe, but he may also be seen with a lance, axe, dart or a bow and arrow.

Scales: To distinguish from the virtue of justice, one side will be higher than the other to symbolise that the balance of life is over.

Sexton's Tools: The tools used by a sexton to dig a grave: the pickaxe, turf cutter and spade.

Torches: When depicted upside down, they represent life being extinguished. When carved as a pair, they are often placed either side of the main body of writing. In the seventeenth century, nighttime funerals were common, especially if the coffin had to be carried some distance from a rural location.

Weapons of Death: These are the weapons usually carried by the King of Terrors: scythe, dart, bow and arrow, lance and axe.

Above left: King of Terrors, Greyfriars, Perth.

Above right: Death and immortality, symbols of Angels of the Resurrection.

Symbols of Immortality

While Death's head may be the most common symbol of mortality, the most common symbol for immortality is again a head – to symbolise the soul. There are various other symbols of immortality that bring a sense of hope to the observer that eternal life will be granted after death.

Winged Soul
This symbol gained popularity in the eighteenth century. The soul is immortal and depicted as a neutral-gendered face, often described as being cherub-faced in appearance with wings that are usually birdlike and feathered. The expressions vary from the sombre to the cheerful and the pensive to the free. Like Death's head, it can be intricately carved or a simple line depiction. Sometimes a frill or feathers are carved below the neck; there may also be part of the torso attached. This represents the deceased person's soul leaving the body at death and ascending. For those who lived a good and virtuous life, the body will then rise to join it on the Day of Judgement.

Angel of the Resurrection
A winged humanoid figure blowing a trumpet or holding it ready for the job at hand. Although they are usually clothed in loose-fitting robes, they can also be depicted naked and cherub-like.

Above left: Winged soul at Forgandenny.

Above right: Winged soul at Errol.

Angel of the Resurrection, Scone Palace.

Cherub
A representation of the soul casting off the body of old age, illness or pain and ready for eternal life.

Crown
The crown of righteousness.

Heart
When used as a symbol of immortality and not as an expression of love between a couple buried together, it signifies either divine love, as God's love will not be extinguished at death, or another representation of the soul.

Lamp
A lamp or upright torch is universally recognised as God, who will bring light to shine eternally on the soul.

Palm Fronds
Usually shown as a pair crossed or in a cartouche. They signify victory over death.

Palm frond in the hands of an angel on Lieutenant General Archibald Fergusson's monument at Dunfallandy.

The Radiance
Also described as the glory of God. This can be depicted in various scenes, from a simple sunburst from the top of the stone to a full scene with the sun shining out of the clouds accompanied by full rays and trumpets.

Snake
When carved in a ring with its head swallowing its tail, it is an ancient symbol of eternity.

Trumpet
Usually seen with an Angel of the Resurrection, they can be depicted as an emblem of immortality on their own. They can be carved as post horns or natural trumpets.

Wheat
When not used to denote an occupation, it indicates a person has lived a long life and has exceeded the age of seventy. It is a symbol of immortality and resurrection, as wheat can come back after it has been harvested.

Symbols of Mourning and Remembrance

> The life of the dead is placed on the memories of the living. The love you gave in life keeps people alive beyond their time. Anyone who was given love will always live on in another's heart.
>
> <div align="right">Marcus Tullius Cicero</div>

Portraits
Portraits on gravestones have taken many forms over the years, ranging from the eighteenth-century tradesman depicted at work to the husband and wife and all their children. There is an incredible example of this at Innerpeffray Chapel: the 1707 Faichney monument. Later masons, often on grander monuments, would have a full relief, half-bodied or facial representations of the deceased. This is a trend that to some extent has carried on to the present day, with loved one's photos or their likeness etched on a gravestone.

The Weeper
Weepers have been used on grave markers since the fifteenth century, but the Victorian period made a lone weeper a popular choice. There is no mistaking the lone weeper as she leans over the grave of the deceased, often her head bent in eternal sorrow as she stands at the grave. Often carved wearing loose-fitting clothes, these stunning grave additions are incredible pieces of art that convey the sheer devastation of the loss felt by the deceased's loved ones.

The Urn
While cremation was relatively new in the Victorian era, the carved urn with cloth draped upon it became a popular choice to adorn the grave of a loved one in the neoclassical revival. Nineteenth-century cemeteries show many graves have a similar style, whether in cities or more rural areas.

Above left: Faichney monument detail.

Above right: One of the twelve Faichney children.

Weeper at Greyfriars, Perth.

Urn and weeper at Dunblane Cathedral.

Symbols of Virtues

One of the most elaborate folk art post-Reformation stones can be found in Greyfriars in Perth. This Faith, Hope and Charity stone has had its order changed to Faith, Charity and Hope, presumably in the order of importance of the virtues to the person who commissioned the stone. Unfortunately, in 1828, this stone from 1651 was repurposed by a Victorian family, obliterating some of the earlier information. The original stone owner was a tailor, as can be seen by some of the tools of his trade among the array of beautifully carved symbols on the stone.

Faith is seen standing by a cross holding a chalice and directing a youth. Charity includes a deathbed scene of the tailor. Above Charity is at a pulpit, again holding a chalice in one hand with a dove perched in its bowl, a symbol of the Holy Ghost.

On the right is a figure holding out the crown of everlasting life, suggesting that it is St Michael. The anchors are clearly visible as a symbol of hope. The most curious figure, however, is that of a half-cockerel, half-human humanoid with wings and a hand. Traditionally, the cockerel was a symbol of Mercury, the messenger of the gods; however, in Christianity, Michael took his place. The cockerel is also a bird associated with the dawn and the reawakening of the new day, rousing people from their sleep, banishing the darkness of the night.

Faith, Hope and Charity.

Emblems of Trade

By Hammer in Hand, All Arts do Stand

Motto of the Guild of Hammermen

The carving of the tools of one's trade occurs in the catacombs of Rome, and the practice made its way to Scottish shores in the seventeenth century. In the early part of the century, the Trade Incorporations were prevalent throughout Scotland, providing financial protection and support for their members against merchants. It was not uncommon in churches to see the Incorporation arms painted on the lofts or marked on the pews where their members sat. Someone who had a trade was grateful to God and wanted their trade to go on their grave marker. As it was considered more important than a family name, sometimes just the initials of the deceased were added.

Abernyte parish churchyard's charming burial ground, set up on a hill with spectacular views all the way down to the River Tay, is home to two remarkable trade stones. The trade in question is that of the fleshers, or what we would today call butchers. Meat was not readily available to the common man due to the expense of caring for the animals. Additionally, food stocks were insufficient to sustain the animals through the harsh months. Therefore, sheep, oxen and goats were most typically slaughtered at Michaelmas, salted for the winter and purchased by those with more wealth. Every part of the animal would be used, with cheaper, less desirable parts prepared in a way that the poorer part of the community could afford (haggis, anyone?).

Symbolic Scenes and Symbols

Typically, a flesher's stone will have the emblems of trade: axe, cleaver, butcher's knife and honing rod. However, at Abernyte, the mason has depicted the fleshers at work. The first stone, erected by Patrick Lowson, a flesher in Glen Lyon, shows the flesher about to start work, weapon in hand, his hound nearby, and a series of animals also clearly visible. The trade emblems have also been carved into a heart.

The scene gives a sense of movement and tells a story rather than just stating facts. The second stone from 1765 commemorates Jean Boyd (1746) and William Paterson (1759). Here, at the tympanum, is a rather violent scene: flanked by a sheep and a goat, an ox is on its back while the flesher carries out his task with seeming gusto. The flesher is also depicted alone further down with his knife in his hand, returning from his sombre task.

There are other trade stones to be found here, showing what a bustling community this sleepy little village had once been in the eighteenth century. There is beautifully carved evidence of trades on nearby gravestones that include wrights, cordiners, weavers and a miller. This latter stone is another of particular note. Erected in memory of Agnes Smith and the couple's children in 1783, the miller and his apprentice are depicted standing on either side of the millstone, their hands gesturing as if reaching out towards it. From this mighty symbol of their trade, a medieval stylised tree of life grows from it. The spiraliform scrolls sprout out both left and right from its trunk.

Below left: Flesher stone.

Below right: Flesher stone.

Miller's stone with the tree of life, Abernyte.

Artists: Brush, paint palette.
Barbers: These stones are a delight to come across, emblazoned with razors, combs, wig stands and sometimes bleeding bowls.
Baxters or Bakers: One of the earliest trade communities formed in Scotland. Symbols include crossed peels, small loaves, spurtles, bannocks and scuffles.
Coopers: Traditionally made a variety of wooden products to hold liquids, such as casks, barrels and buckets, though they were known to also make wooden rakes and other such implements. Carvings include a cooper's hand adze, the cooper's side axe and dividers.
Cordiners or Shoemakers: The cordiner, along with the hammer men, were allowed to use a crown on their symbol. The most popular symbol is the half-moon cordiners knife topped with the crown, but they may also be pliers, sole cutters, awl, lasts, other cutting tools or, indeed, shoes.
Dyers: Glove, tongs, dyers press.
Farmers: The plough, though the use of the stock and the coulter are most commonly used. It may also be accompanied by a scythe, pitchfork or ox yoke. At Forgandenny is an exquisite example of the whole plough and ox yoke.
Fishermen: Rowing boat, net, fish and oar.
Fleshers or Butchers: No explanation really needed here. Most include the flesh knife, cleaver, axe and honing steel; animals of their trade may also be included.
Forester: The axe, pruning knife or trees – with or without their branches cut.
Gardeners: A whole variety of symbols can be used for the gardener, including a spade, rake, pruning knife, measuring reel, flags, garden produce, trees or even sometimes a watering can.

Gamekeepers: Particularly sought after on large rural estates, they may include guns, powder flasks, dogs, birds and even fishing rods.
Glovers: Glove, shears, stretchers or buckles.
Grooms: Lamp, brush, the fleams.
Hammermen: They had the honour of including the crown above their universally recognisable tool of the hammer. The hammermen were essentially anyone one who used a hammer to hit off metal as part of their trade. Blacksmiths would often add an anvil or such like.
Maltmen: Grain shovel, mash oar, weedock and broom.
Mason: Dividers, square, mell and trowel. A master mason may also include the three castles.
Merchants: A reversed number 4, known as the 'Merchants' 4'. It can sometimes be inverted and include initials.
Millers: Mill rind, millstone, brush, scales, grindstone and sometimes wheat sheaves.
Tailors: Goose iron, pressing iron, shears, needle, bobbin, pin and thimble.
Waulkmiller: Wool shears, mill rind and fulling pot.
Weavers: The shuttle is nearly always used, but it can also be accompanied by a frame, stretchers, comb or rollers. A master weaver of the guild may have the trade symbol of the leopard with the shuttle in its mouth.
Wrights: Dividers, square, hammer, axe and saw.

Barbour stone.

Dyer.

Fisherman.

Glover.

Weaver.

Dual trade of weaver and tailor.

2

The Picts

Since death is one of the most significant parts of a person's life, ever since the beginning of time, man has made much of his burial customs.

Dane Love

The Picts were the descendants of the native Iron Age people who lived in the north-east area above the River Forth. They particularly flourished between the fourth and ninth centuries in the period often referred to as the Dark Ages. The term 'Pict' comes from the Roman name 'Picti', meaning 'painted people', and is believed to refer to the practice of the people to paint or tattoo their bodies. The Romans first used the term to distinguish between Roman and non-Roman Britons during the occupation of northern Britain, though it subsequently came to refer to those north of the River Forth.

Irish missionaries started to introduce Christianity to Scotland from the fourth century onwards, making sure to cause the least disruption to pagan worshippers. By using understanding and patience, they replaced the pagan idols with a new god, gradually phasing out the old ways of worship. Many of Scotland's kirks and kirkyards occupy prehistoric burial grounds or places of worship. As Christianity was introduced, the use of symbols from both cultures was implemented; for example, a Christian cross would be completed with Celtic knotwork, interwoven with Pictish animals and symbols. There are instances where stones are found to be Pictish on one side and Christian on the other. The use of Pictish symbols became repressed and, as such, have now been divided into three categories:

Class I – Stones containing purely Pictish symbols.
Class II – Stones bearing both Christian crosses and Pictish symbols.
Class III – Usually crosses or cross slabs which horsemen appear upon.

There has been some doubt cast over these Pictish stones being grave markers, as in some cases there is no evidence of burial and specific symbols to an area are thought to represent a family. There have been many attempts to understand the Pictish symbols carved on these stones, but without any written context we simply do not know their exact meanings. They have roughly been divided into two categories. The first deals with the artistic and cultural influences that may have contributed to the design, while the second indicates symbols that are trying to convey a specific message. Experts have identified forty motifs that are specifically Pictish symbols. These motifs are generally identified in three groups: animals, abstract motifs and everyday objects.

Left: Pictish stones at Meigle.

Below: Examples of Pictish symbols: rod, flower, mirror and comb, rod and crest, salmon, Pictish beast, cauldron and eagle.

While the animals are easy to identify, there is one that is rather curious and is usually simply referred to as a 'Pictish beast' when being discussed. This strange creature is sometimes likened to an elephant, though it represents no known animal. In fact, it is the most commonly used animal symbol. Due to it not actually representing a real animal, it is surprising to learn that its form is unusually consistent on different stones across the country. The animal appears to have a long, trunk-like snout with a crest on its head and it generally looks down to its 'feet' which are more like spiral structures and look like small wheels.

The Dunfallandy Stone, Pitlochry

About a mile from the centre of Pitlochry, on a hill once described as the 'Mausoleum Mound' due to the private burial ground of Lieutenant General Archibald Fergusson, is the Dunfallandy Stone. Known locally as Clach an t-Sagart or 'the Priest's Stone', it dates from around the eighth century. This red sandstone Pictish cross slab is one of the finest examples to survive in what is believed to be its original position. There was an early source that claimed that it once stood next to a chapel at the Pass of Killiecrankie, but there is no archaeological evidence to suggest this, so it may be a confusion of location as an early chapel is believed to have once stood on the mound.

The stone stands at about 1.5 meters high and is 6 cm thick. On one side there is a beautiful cross carved in relief with decorative panels depicting typical Pictish animals and angels that are mainly looking towards the cross itself. On the other side is a fantastic scene framed by two elongated sea beasts whose tongues reach out to lick at a human face situated between them. Just below this are three symbols: a Pictish beast, a double disc and crescent and a V-rod. Below this, a cross with its base extended out to make a floor on which two chairs sit facing the cross. Upon these chairs are two seated clerics in full-length hooded robes. Another hooded cleric is carved on horseback beneath them. The horse gives the impression of movement, while the cleric's head snugly fits into the space under the cross. Immediately in front of the horse is another crescent V-rod and a Pictish beast. At the bottom are a hammer, an anvil and an incised pair of tongs. Unfortunately, due to the reflective glare of the glass that keeps the stone safe, it is difficult to photograph.

There has been much debate about the meaning of this scene, with no one particular description being agreed upon. One train of thought is that it represents St Paul meeting St Anthony in the desert, though another theory is that they are contemporary people, either secular or religious, with a symbol assigned to each of them either as a caption or an attribute of theirs.

Private burial lair of Lieutenant General Archibald Fergusson.

The stone's shelter.

The Dunfallandy Stone.

3

The Covenanters in Perthshire

For Christ's Crown and Covenant.

While the plight of the Jacobites in the eighteenth century is well known across the world, reaching its unsuccessful conclusion at Culloden in 1746, fewer people are aware of one of the longest campaigns for the freedom to worship without persecution in Scotland's history. For fifty years the Covenanters fought to keep the state and religion separate, with hundreds of Scots, especially in the south-west Lowlands and Fife, willing to face death rather than accept the king's authority over their Presbyterian Church and that bishops and various forms of Episcopal governance could be introduced. Thousands died in battle fighting for their belief, while many thousands more were banished to distant lands to work as slaves. The Covenanters believed they were God's chosen people, with their story forming in 1560 with the abolition of the Roman Catholic Church hierarchy and the establishment of the Presbyterian Church of Scotland. In 1637, Charles I sought to assert the monarch's authority over the Church of Scotland, a move that had been tentatively planned by his father. First, he wanted to replace John Knox's liturgy, the Old Book of Common Order, with the Book of Common Prayer, which the Archbishop of Canterbury had compiled based on Episcopalian principles. On Sunday 23 July 1637, the uncontrollable anger of the congregations of Presbyterian churches at the papist sermon was evident as people began to riot within the churches. This led to a group of representatives being elected to persuade the king to revoke the new religious guidelines and liturgy. A document was drawn up stating that while they were loyal to the king, people would not obey his ruling on this matter. The document was the National Covenant.

This was the start of one of Scotland's darkest periods of history, ending with the Killing Times, which concluded with the publication of the Act of Tolerance in 1687 and the Glorious Revolution of 1688. Hundreds of ministers were ejected from their parishes by the Scottish Parliament for their failure to accept the king as head of the Church. These men would instead hold illegal services in fields, sheds or barns which were known as a conventicle. Their congregations would follow them rather than attend the Episcopal curates installed in their churches. This, in turn, led to an Act against conventicles that made it illegal to hold or attend a service.

While Greyfriars Kirkyard in Edinburgh is arguably the most famous place in Scotland associated with the Covenanters, it was widespread throughout Lowland Scotland and Perthshire was not to escape. At the same time, the remote Gaelic-speaking Catholic Highlanders had no interest in supporting the Covenanters, but many of the Lowland parishioners were wholeheartedly committed and ready to

die. While many indeed did die for their beliefs, there are not many gravestones to reflect the number, with many being added at a later date.

The tranquil kirkyard of Tibbermore displays no memorial or indeed any evidence at all of the reputed 200–300 Covenanters buried here after the Battle of Tippermore (as it was traditionally called) on 1 September 1644. Despite vastly outnumbering the Royalist troops under the command of a man who had started out on the side of the Covenanters before swapping sides, James Graham, Marquess of Montrose, it was the Royalist army that was victorious.

Supported by the MacDonalds of Antrim, Stewarts and Robertson clansmen, as well as some Atholl Highlanders. The battle itself lasted about half an hour, with the majority of the 1,300 men killed in the aftermath as Montrose pursued them. At 9 p.m. that evening, the city of Perth surrendered without a fight and the 800 men captured were temporarily held prisoners in St John's Kirk. With no physical evidence in Tibbermore Kirkyard, it is just the reports of the time that tell us they are buried there. Being Montrose's first engagement after swapping allegiances, the reports were extensive, though there could have been some exaggerations of the numbers, considering how small the original burial ground is.

The burial ground at Tibbermore.

Individual gravestones to Covenanters are sadly scarce in Perthshire, though five are known to exist. The oldest of the Perthshire Covenanters stones can be found inside the church at Longforgan, dated 1643 for Andrew Smyth, describing him as a true Covenanter.

At Ecclesmagirdle is the stone for Thomas Small, 1645. While inside the vestibule of the beautiful Forgandenny Kirk is Andrew Brodie, 1678. Lieutenant Colonel William Cleland, 1689, was buried just outside the nave at Dunkeld Cathedral and while a small uninscribed stone marks the spot, a memorial to him can be seen inside the church.

One man who foretold the death of Archbishop Sharp during a Conventicle can be found in the quiet corner of Dron Kirkyard, past the sadly decaying church building. This is the stone to Revd John Wellwood, who died in Perth in 1679. With the burial of the preacher denied in the town, a group of his friends took him to Dron, only to find the gates locked, barring entry. Not to be deterred, they carried his body over the wall and buried him there.

Grave of Revd John Wellwood.

4

The Scottish Episcopal Church in Perthshire

It is all too true that the history of religion in this land makes very distressing and painful reading.

Most Revd John C. H. How

With Perthshire being a region of two halves, it is unsurprising that religion would also follow this form. From the Lowland Presbyterians to the Highland Episcopalians and Catholics, Perthshire certainly had its fair share of conflicts due to religion and politics, and they would have devastating and lasting effects that the area never really recovered from and displaced people all over the world. After the brutality of the Killing Times, it would be assumed that the country would have time to heal; however, sadly, that's far from the truth. The Stuarts had been in favour of an Episcopalian Scotland, so when James VII was forced to leave and William and Mary came to the throne in 1689, disestablishing Episcopacy in Scotland, the Presbyterians in the south-west of the country wasted no time in evicting Episcopal clergy from their parishes or as it's been known, to 'rabble the curates'. In 1690, the Episcopalian Lord Tarbet noted that 'the Presbyterians are more zealous and hotter, the others more numerous and powerful'.

North of the River Tay the Episcopalian clergy were able to continue ministrations in the parish churches due to the fierce loyalty of the congregations. While not in Perthshire, an example of this loyalty was seen in the parish of Glenorchy in Argyll. When an attempt was made to install a Presbyterian minister appointed by the Earl of Argyll, all but Mr David Lindsay, the minister in residence, refused to speak to him; Lindsay greeted him kindly and accompanied him to church on the Sunday. It was noted that the whole population of the district came, but stopped short of entering the building. Twelve armed men refused his entry to the church, telling him that he must accompany them. Mr Lindsay tried to reason with the men, but a piper was ordered to play a death march as they took away the minister. He was then made to swear on a Bible that he would never return or attempt to disturb Mr Lindsay. Mr Lindsay continued to live in the parish another thirty years, dying the Episcopalian minister of Glenorchy.

The accession of George I provided the occasion for a revolt of the Jacobites in favour of the son of the last Stuart king. Highland Episcopalian clergy were noted as being active in their support of a Stuart monarch once more. An Act was passed at Westminster in 1719 which enacted that no person should be committed to officiate in any Episcopal meeting house or congregation where nine or more persons were present, in addition to members of the family, without praying for King George and his family. At the time of the Jacobite rising of 1745, it was not clear how many

members of the Episcopal Church there were throughout Scotland, but it has been suggested in the north that a majority of the middle and lower classes still adhered to the Episcopal faith. A profound wave of Jacobite enthusiasm passed through the Highlands of Scotland when word spread that the grandson of James VII, Prince Charles Edward Stuart, had landed to claim the ancestral crown for his father, James. Many Episcopalians wanted to see the restoration of the Stuart dynasty. The Duke of Cumberland marched his forces to Aberdeen and prepared to engage the Jacobite Army. On the march there he was determined to destroy Episcopal chapels where he could. After the infamous Battle of Culloden, the return march saw a greater severity as penal laws were put in place to suppress the ministrations of the Episcopal clergy, who were regarded as being largely responsible for the rebellion.

The accession of George III brought favourable change to the Scottish Episcopal Church, as the new king had no desire to enforce the laws against Episcopalians in Scotland. This was encouraging for the clergy, which influenced them to discharge their pastoral duties openly, and their congregations were encouraged to restore or erect buildings or even lease premises for worship.

Kilmaveonaig Church is a beautiful Episcopal chapel rebuilt in 1794 on the site of an old parish church. Its very earliest foundation goes back to the thirteenth century. There has been much disagreement about whether the church is dedicated to St Beoghna, Abbot of Bangor, or St Adamnan, Abbot of Iona and the biographer of St Columba. However, local sentiment leans towards the latter, who is known to have preached in the area and was buried at nearby Dull. Regardless of which is true, it is now dedicated to St Adamnan.

Kilmaveonaig Church.

Through the allegiance of the laird and ministers, the chapel was closely associated with the Jacobite cause. In 1715, Revd Duncan Stewart read the Jacobite proclamation from Kilmaveonaig's pulpit. After Culloden in 1746, the building was partially destroyed by government troops and was not fit for worship. Not that it would have mattered regardless, as in the same year an Act of Parliament forbade a congregation to be more than four people. The wealthy, who had large homes with many rooms off a central hall, could get around this by the minister preaching in the hall while four or fewer people listened from each room. Revd Walter Stewart, who had watched the soldiers destroy his church, cared not for the Act of Parliament, nor did he have a large house; neither stopped him from performing divine service in his own home every Sunday for nearly a year, to which more than four people attended, as well as his own family. For this, he was committed to Perth Tolbooth for six months.

One hundred years after the rebuilding of the church, Revd Christopher Bowsted undertook an enthusiastic role in its restoration. The north and east galleries were removed, the Robertson coat of arms (with its motto 'dinna waken sleeping dogs') was moved to the west gallery, the vestry was rebuilt, the church reroofed and slated, the plaster ceiling replaced with an arched wooden roof and the windows had stone mullions inserted.

During restoration it was hit with a scandal of sorts. Accusations started to fly of the 'wanton interference with an ecclesiastical fabric' and a cartload of earth 'with the dust of the departed' taken to the garden of 'Episcopal clergyman's'. The problem had been that during the rebuilding of the church, the earthen floor had been dug up with a large portion from the old east gallery and left in an almighty heap against the churchyard's back wall. Within the soil fragments of human bone could be seen and the committee were quick to make their disapproval known, as they believed it was excavated from the burial ground of the Robertsons of Lude (those of the motto 'dinna waken sleeping dogs!).

Several options were discussed, such as the soil being placed within the church walls in its former site. However, this was rejected due to the advanced state of repairs already undertaken and the difficulty of doing so. The option that was unanimously agreed upon was that a large pit be formed in an unoccupied part of the churchyard. It should be between 4 and 5 feet deep, an area large enough to take all the soil excavated from the church floor, including the cartful in the minister's garden! The pit was dug at the back of the church on the sloping area between the building and the then back wall of the churchyard. There has since been an extension to the burying ground behind this wall and the area of the pit remains without any burials or gravestones.

The restoration even hit the press, and a somewhat tongue-in-cheek letter was printed in *The People's Journal*.

Sir- In connection with the sacrilegious digging up and carting away of human bones at the above church, can any of your readers tell me whether the following old rhyme is to be found?

'When Kilmaveonaig's dead shall lie
Long weeks exposed beneath the sky,
Woe to the priest, the wretch that planned!

Woe to the race that holds Lude land!
Glad am I, though my bones be there
I shall not live to shed a tear.'

While there had been mutterings again, it evidently calmed and peace was restored; in fact, an appreciation of the restoration was expressed. The silver chalice and paten still in use were given by Harriet Anne Morehead in 1898 as a thank-offering for the restoration. Additionally, there is a window inside the church, above the Robertsons' vault, with the following: '"Write the vison and make it plain" from Habakkuk 2:2 … dedicated to the memory of the Rev. Christopher Bowstead.'

Window dedicated to the memory of Revd Christopher Bowstead.

5
Clan Burial Grounds

There is a most curious burial ground in Killin. While most people are captivated by the splendour of the falls of Dochart, a horizontal waterfall that has inspired countless artists, few turn around to look over the other side of the bridge. Here, they would see the burial ground of the MacNabs on the island of Innis Bhuidhe.

The MacNab clan is said to have been founded by one of the sons of Kenneth Macalpine. After being on the wrong side against Robert the Bruce, the clan's fortunes were turned when Gilbert Macnab of Bovain received a charter from David II. Over the next two centuries they consolidated their lands, which would stretch from Tyndrum to beyond Killin.

Burial ground of the Clan MacNab.

This type of burial site on an island is common across Scotland. There is some merit to the notion that the burial of clan chiefs followed similar ritual to the burial of royalty, such as was done on Iona. It is likely, however, that burying the dead on an island protected the deceased from wild dogs or, in earlier times, wolves. Stepping down the steps from the bridge at the west end of the island, visitors then need to make their way along the path, crossing over the foundations of two Iron Age forts until reaching the burial ground. Here, within its locked enclosure, is the last resting place of the clan chiefs.

There are few clans treated as badly as Clan Gregor or the MacGregors. Forced out of their ancestral lands in Argyll, they were turned into outlaws through circumstance rather than by choice. The men were hunted for bounties while the women were branded; even the use of their name was forbidden under pain of death for nearly 200 years. In 1775, by an Act of Parliament, the name MacGregor was allowed to be used once more.

Rob Roy McGregor is one of Scotland's most famous Highlanders, thanks to both a fictionalised account of his lifetime in 1723 entitled *The Highland Rogue* by Daniel Defoe (who also wrote *Robinson Crusoe* about the exploits of Alexander Selkirk) and later to Sir Walter Scott, who wrote about the legendary cattle drover in the nineteenth

MacNab burial area at the east of the island.

century. This was during a period of literary enlightenment when the romanticism of Scotland was gripping the entire British Isles.

Born in 1671 at Loch Katrine, he and his family used the name despite it being outlawed. While some people see him as a hero, a sort of Robin Hood, others have described his actions as being more villainous and corrupt. His life is shrouded in mystery and swathed in folklore. What is known is that he ran an effective protection racket for local landowners, yet he used the money to support members of his family and clan. For a fee, he would ensure that cattle were kept safe; if payment was not forthcoming, however, the cattle would simply disappear. This did keep the area safe from more ferocious raiders as MacGregor's reputation was well known. A large man for the era, he was known to some as 'Red Rob' due to the fiery colour of his hair and temperament. His reputation gained him the trust of powerful and wealthy men who trusted him to purchase cattle on their behalf and to move large herds through the glens. His greatest patron was the Duke of Montrose, though he found himself on the wrong side of the duke after a disagreement over money and allegations of perjured testimony. He was declared a criminal and forced to flee to the forgotten and hidden areas around Loch Lomond. Stories of the legendary Highlander would become well known during this time. A story goes that a widow was unable to pay her rent, so MacGregor gave her the coin then relieved the rent collector of his monetary burden not long after.

One of the unusual things about Rob Roy McGregor, considering the life that he led, was that he died of old age in his bed. His feud with the Duke of Montrose was to continue until 1722 when he was finally forced to surrender and was imprisoned for a while. He was later pardoned in 1727. He died in his home of Inverlochlarig Beg on 28 December 1734 and was buried at Balquhidder. He was to be joined there later by his wife and two of his sons.

There is no dispute that he died at Balquhidder, though there are some who have questioned whether Rob Roy MacGregor is actually buried in the kirkyard there. In more recent times, it has become known as the McLaren burial ground, with the current chief of the McLarens stating that Rob Roy McGregor is not buried there; however, there is evidence of Macgregors being buried there long before the McLarens were. The three stone slabs that are in place at Rob Roy MacGregor's burial spot have evidently been reused from an earlier grave. The metal fencing that surrounds them was added in the early twentieth century to stop people from wearing away the carvings upon the slabs. An additional marker was added, which simply says, 'MacGregor Despite them'. This line is memorialised in a verse in Sir Walter Scott's poem 'MacGregor's Gathering'.

> While there's leaves in the forest, and foam on the river,
> MacGregor, despite them, shall flourish for ever!
> Come then, Grigalach, come then, Grigalach,
> Come then, come then, come then.

On the south side of Loch Rannoch is the hamlet of Camghouran. In the nearby graveyard of St Michael's is Clach nan Ceann, 'the Stone of the Heads'. The graveyard has been used as an ancient Clan Cameron burial ground for centuries, but this stone holds the most tragic of Cameron deaths. As the story goes, in the thirteenth century

Above: Balquhidder.

Left: Postcard of Rob Roy's grave, *c.* 1922.

The grave of Rob Roy MacGregor.

there was an attractive young woman named Martley MacGregor who attracted the attentions of two fine young men, Ewan Cameron and a clan chief of the Mackintoshes. It was Cameron who won her heart and the two married, going on to have four sons together and living a happy and harmonious life. The years passed and Macintosh went to Perth for the St Michael's day market to buy arrows. Selecting the very finest, he decided to leave purchasing them to the next day as an evening with friends had his attention. Meanwhile, Cameron was in Perth at the same time and went to buy arrows. The fletcher explained that they were reserved, but Cameron would have no other, so paid extra. The next day, MacIntosh returned to find the arrows had gone to his rival. This must have been the final straw as he went with his companions and kinsman back to Camghouran and confronted his former love interest, demanding that she leave her husband to go with him or he would kill her sons. She refused, not believing the man she once considered for a husband of such cruelty. Mackintosh took the boys one by one, dashing their heads against the great stone that would become Clach nan Ceann. Only the youngest survived, hiding in his mother's skirts. Cameron and his kinsmen returned, rushing to the area where he could hear his wife's screams coming from. Seeing his dead sons, a great and bloody fight broke out, leaving all but one of the Mackintoshes dead. The remaining man swam to safety but was caught by a MacGregor, who swiftly dispatched him. It is believed the burial site was named St Michael's as the terrible murders happened on St Michael's day, 29 September.

The Stone of the Heads.

6

Preeminent Men

Away with the Fairies

> In memory of the Rev. Robert Kirk, who went to his own herd, and entered into the land of the people of peace, in the year of grace sixteen hundred and ninety-two.

Aberfoyle Kirkyard is the burial place of the fairy minister Robert Kirk. Kirk was known in the late seventeenth century for publishing one of the first Bibles in Gaelic. However, today he's perhaps better known for his work *The Secret Commonwealth of Elves, Fauns and Fairies*. He died on 14 May 1692 at the age of forty-seven. After his death the legend quickly spread that he had not died but instead been taken away by the fairies to become the chaplain to the Fairy Queen. The explanation was said to be to stop him from revealing more secrets of these covert creatures. It is interesting to note, though, that Kirk wrote himself that the sìth (the Gaelic term for fairies) had no kings or queens. It would be over 100 years before Sir Walter Scott released Kirk's unpublished work in 1815 under the title *The secret Commonwealth or an essay on the nature and actions of the subterranean and for the most part invisible people heretofore going under the names elves fauns and fairies or the like among the low country Scots As described by those who have second sight 1691*. The copy that Scott borrowed from the previous library was never seen again – like many of his treasures, it had been 'acquired'.

Born the seventh son to James Kirk, the minister of Aberfoyle, Robert became the minister of Balquhidder in 1644, where he would serve for nearly twenty-one years before returning home to take up the role of minister of his father's former parish. On the evening of his death, Kirk had been walking behind the kirkyard clad only in his nightgown when he seemingly collapsed into a swoon, which was then taken by all as his death. A funeral took place, but it's been stated that no body belonging to Robert was interred in the grave and that the coffin had instead been filled with stones.

It was a later minister Aberfoyle who made the claim that Kirk did not actually die on the hill but had been taken away by the fairies for revealing their secrets, imprisoning him in the fairy Knoll known as Doon Hill. During the christening of his son, also named Robert, he appeared in spectral form to his cousin Graham of Dockery and begged the man to throw a dagger above him for iron is a bane against fairies and could release him from his captivity. However, in his astonishment at seeing the dead minister he was awestruck and the opportunity was lost. When the English folklorist Katherine Briggs visited Aberfoyle in the 1940s, locals told her that people crossing the humped bridge near the Faerie Hill would sometimes feel a weight upon their backs. This is said to be the soul of Robert Kirk begging to be freed. The area became a tourist attraction in the twentieth century, with postcards even noting the Fairy Knoll.

Postcard of the graveyard and Fairy Knowe at Aberfoyle.

Big Tree Country

Perthshire is often referred to as the 'Big Tree Country' of Scotland, largely due to the Douglas fir. The tree, however, is not native to Scotland, having been introduced in 1827 by Scottish botanist David Douglas. Scotland's climate is well suited to growing the conifers of north-western America. While he discovered thousands of species of trees, plants, mosses and seaweeds, only about 240 trees and plants were suitable for Britain's climate. From lupins to asters and the Sitka spruce to Douglas firs, Douglas was responsible for dramatically changing both the British countryside and gardens forever. He amassed such a great number of different species of conifer that as a result of his endeavours around half of Britain's woodlands are coniferous.

Born in 1799 in Scone, he expressed a deep interest in plants from an early age, so instead of following his father's trade as a mason, he became an apprentice gardener at the age of eleven at Scone Palace. Completing his apprenticeship, he moved for a time to Valleyfield House and then went on to Glasgow Botanical Gardens, where he attended lectures by William Jackson Hooker. It was this man who was to transform Douglas' life and set him off on a path that would eventually take him to North America.

Over three expeditions, Douglas would earn the title of the greatest plant hunter of the nineteenth century. It would seem he should have gained another title though, that of being somewhat unfortunate in his travels as he was often plagued by bad luck and accidents. His catalogue of calamities included encounters with grizzly bears, miscommunication with natives, near drownings, exhaustion, infected wounds, loss

of his possessions, starvation, heat stroke and snow blindness that would affect his eyesight from then on.

After a few years back in Britain, Douglas became bored and in need of adventure once more. His irritability caused his friends to encourage him to return to America. In 1830, he left for his third and final expedition, never to return home. After an extensive exploration of California, he made his way to Hawaii. An initial three-month stay was extended. During this time, he undertook a great deal of botanising and exploration, becoming one of the first Europeans to reach the summit of Mauna Lao volcano.

David Douglas died on Hawaii at Laupāhoehoeon on 12 July 1834 aged thirty-five. It was claimed that he had fallen into a trapper's pit that a bull had also become trapped in, resulting in being gored and trampled to death. The explanation of his death, however, was not accepted by all. Douglas had become a popular figure, well liked on the islands and had an excellent reputation with the missionaries and their families. Revds Diell and Goodrich, along with a carpenter employed to build a coffin, noted that the gashes of Douglas' head did not appear to have been caused by

Memorial to botanist David Douglas.

bull horns or hoofs. They endeavoured to preserve the body with salt and sent it to Honolulu to be examined. No satisfactory conclusion of this was given, and the famed botanist was buried in an unmarked grave near Mission House. Rumours persisted that he had been murdered by bullock hunter Edward 'Ned' Gurney. The Englishman, an escaped convict who had been convicted of larceny and sent to Botany Bay in 1819, had escaped, arriving in Hawaii in 1822 on board the *Mermaid*. Douglas had accepted the hospitality of the man the previous evening, staying in his hut. While Douglas's diaries and specimens were found, the bag of gold coins that he had been seen with was never discovered.

In 1847, at Scone Old Parish Kirkyard, a great memorial was erected by 'The Lovers of Botany in Europe'. The baroque monument is, unsurprisingly, decorated with finely sculptured, flower-filled vases and large floriated scrolls; there is a wide variety of flora to be seen among the skilled carvings.

Bonnie Dundee or Bluidy Clavers

John Graham of Claverhouse, Viscount Dundee, is one of the most contentious figures in Scottish history. Revered as a gallant hero to the Highlanders, a loyal servant to the Stewart crown and a man of courage, he was Bonnie Dundee. However, to the Lowland Covenanters, he was a ruthless oppressor who earned the title 'Bluidy Clavers'.

Beginning his military career in the French army of Louis XIV, he distinguished himself at the Battle of Seneff in Belgium in 1674. On his return to Scotland four years later, he was commissioned in Charles II's army and given the orders to suppress the conventicles. The very task that earned him the title of 'Bluidy Clavers'. His loyalty to the Stewarts was rewarded a decade later when he was created Viscount Dundee by James VII. The following year, Scotland followed England in awarding the crown of Scotland to William and Mary on the grounds that James had effectively abdicated. Dundee disagreed and tried in vain to have the decision overturned; in this he failed, so fled Edinburgh to gather an army at Blair Castle in support of the Stewart king and thus the first Jacobite uprising had begun.

Although the Jacobites were victorious at the Battle of Killiecrankie, the first battle of the uprising, its leader, Bonnie Dundee, was mortally wounded leading the charge. He died sitting against a standing stone nearby which is now known as Claverhouses's Stone and was interred in the vault at St Bride's now ruinous church at Blair Castle. About 100 years later, General William Robertson of Lude was informed that the vault had been opened and that the body of a man who had been buried in his armour had been discovered. He hastened to the church to find the grave digger had disposed of most of the armour to a band of passing tinkers, who wanted it for its brass rivets. He was just in time to rescue the helmet and also the breastplate, which are now in Blair Castle. On the date of the bicentenary of the battle, an inscribed plaque was unveiled in honour of Viscount Claverhouse.

> Within the vault beneath are interred the remains of John Graham of Claverhouse Viscount Dundee who fell at the battle of Killiecrankie 27th of July 1689 aged 46. This memorial is placed here by John 7th Duke of Atholl KT, 1889.

John Graham of Claverhouse, Viscount Dundee.

The Father of Radar

The most famous grave at the Holy Trinity Church in Pitlochry belongs to Sir Robert Watson-Watt (13 April 1892 – 5 December 1973). While his name may be unfamiliar to most people, his invention certainly is not. Sir Robert was once reportedly pulled over for speeding in Canada by a radar gun-toting patrolman. While being issued with a ticket, it is reputed that he remarked to the man, 'Had I known what you were going to do with it, I never would have invented it!'

Born in Brechin, Sir Robert would become a Scottish pioneer of radio direction finding and radar technology. He began his career in radio physics at the Met Office, studying various ways to track thunderstorms using radio signals given off by lightning. This work led on to the 1920s development of high-frequency direction finding (HFDF or 'huff duff'). This allowed operators to determine the location of enemy radio in seconds, and it became a major part of the network of systems that helped defeat the threat of German U-boats during the Second World War. There is a memorial at Daventry, the site of the first successful radar experiments, which reads:

> Birth of Radar Memorial.
> On 26th February 1935, in the field opposite Robert Watson-Watt and Arnold Wilkins showed for the first time in Britain that aircraft could be detected by bouncing radio waves off them. By 1939 there were 20 stations tracking aircraft at

distances upto 100 miles. Later known as RADAR. It was this invention more than any other that saved the RAF from defeat in the 1940 Battle of Britain.

In 2013, Sir Robert Watson-Watt was posthumously inducted into the Scottish Engineering Hall of Fame.

Sir Robert Watson-Watt.

7

Notable Women

The Wives of James IV

While the marriage of James IV to Margaret Tudor, sister of Henry VIII of England, is well known, his first 'wife', Margaret Drummond, is more famed for her death rather than her life with the king. Visiting the breathtaking Dunblane Cathedral, the most interesting grave here is found within the choir of the building rather than in the graveyard. The blue marble slabs mark the resting place of the renowned beauty of Margaret Drummond and her two sisters.

James' relationship with Margaret predates his accession to the throne. Her closeness to James ensured her family were treated favourably. Her father, Lord John Drummond, not only sat in the king's first Parliament in 1488 but also served as the constable of Stirling Castle. While some rumours suggested James had already married her in secret, others state a marriage was imminent. Regardless, Margaret's position in the king's life was a disaster to both the Scottish and English governments, who were hatching a plan to unite the countries in marriage. There were moral arguments against the king's marriage to Margaret Drummond, as it was suggested that they were related within 'physical degrees' and a papal dispensation would be required. When Margaret suddenly died at Drummond Castle on 3 May 1501 with two of her sisters, Euphemia and Sybella, the accusation of murder was quick to be voiced. The chief suspect was Euphemia's husband, Lord John Fleming. This accusation was believed by James' future wife, Margaret Tudor who wrote about the fateful breakfast in 1502 and stated that

> 'For Fleming evil that he had to his wife, cause poison three sisters, one of them his wife and this is known as truth throughout Scotland.'

There was no evidence and food hygiene of the time meant that nothing was ever done, in fact Fleming would go on to hold a position of great importance later on as one of the lords in charge of the infant king James V! He was eventually assassinated himself while out hawking by John Tweedie of Drumelzier.

James and Margaret Drummond had a daughter together of whom he favoured above all his other illegitimate children. Margaret Stewart, known as Lady Margaret, was housed at Edinburgh Castle under the care Sir Patrick Creighton and his wife, along with two young African girls referred to as 'Moorish lassies' who were her ladies in waiting, Ellen and another Margaret. The trio were often seen together and fashionably dressed – another example of the king's high regard for his daughter. It is perhaps curious to note that Lady Margaret was around the same age as her future stepmother.

Left: Site of the poisoned sisters' graves at Dunblane Cathedral.

Below: Margaret Drummond.

SIT DEO LAVS ET GLORIA DEFVNCTIS MISERICORDIA

TO THE GLORY OF GOD
IN MEMORY OF MARGARET ELDEST DAVGHTER OF
JOHN Ist LORD DRVMMOND BY TRADITION PRIVATELY
MARRIED TO KING JAMES IV AND POISONED AT DRVMMOND
CASTLE WITH HER SISTERS EVPHEMIA AND SYBILLA
BY SOME OF THE NOBLES WHO DESIRED THE KINGS
MARRIAGE WITH PRINCESS MARGARET OF ENGLAND
THE THREE SISTERS WERE BVRIED BENEATH THESE
SLABS IN THE CHOIR OF THE CATHEDRAL OF WHICH
THEIR VNCLE WALTER DRVMMOND WAS DEAN AD 1501

Two years later, on 25 January 1503, the marriage was conducted by proxy between the thirty-year-old king of Scotland and his thirteen-year-old bride at Richmond Palace in the presence of the King and Queen of England, with the Earl of Bothwell standing in for James. Six months later the new Queen of Scotland joined her husband.

Margaret Tudor led a life of great upheaval and at times deep sadness. James IV was known for his wandering eye; however, he showed his young wife affection, kindness and was ever generous with his gifts to her. She bore him a son, the future James V, but tragically, eighteen months later, she was widowed at the age of twenty-three. Her husband fell at the Battle of Flodden in 1513 when his forces went up against those of her brother after Louis XII of France requested the aid of his Scottish ally. Margaret sat at the palace of Linlithgow watching out for her husband's return, only to be met with the news of his death. While made regent of her son in the king's will, she remarried and lost this position. Two unhappy marriages, a fractious relationship with her brother and later an estrangement of sorts from her daughter and an uneasy relationship with her adult son, her life drew to a close at Methven Castle on 18 October 1541. She was buried at the Charterhouse in Perth. The king and his household were provided with expensive black clothes for mourning. Unfortunately, Margaret's eternal rest was to be disturbed in 1559 when the Charterhouse was destroyed in the Reformation. Margaret was not the only royal to be unceremoniously disturbed. James I of Scotland and his wife Joan Beaufort, who were also interred here had their final resting places desecrated by the riotous mob of the reformed religion. King James VI Hospital now occupies the site, with a monument marking the former site of the priory at the Hospital Street/King Street corner.

A Pre-Raphaelite Beauty

> This is a story of two men of genius and a beautiful woman
>
> The Order of Release

Euphemia Chalmers Gray was the woman behind some of the greatest paintings of the Victorian era but was also at the centre of one of Victorian Britain's biggest social scandals. It was a situation deemed so scandalous that Queen Victoria refused to have her at any official occasions she attended until after the death of her second husband.

Effie Gray, 'the Fair Maid of Perth', was born on 7 May 1828 to layer and businessman George Gray and Sophia Margaret Jameson. She was one of their thirteen children, who all resided at Bowerswell House at the foot of Kinnoull Hill, the former home of John Ruskin's grandparents. She was, in fact, born in the very room where her first husband's grandfather had died by suicide and as such her mother-in-law, who witnessed the incident, not only held a morbid superstition against Perth but also the people of the Scottish city. Her early childhood was rather uneventful until she attended the Avonbank School near Stratford-on-Avon in 1842. The reason for this location was in part due to her parents wanting her to lose her Scottish accent. Having met John Ruskin, a friend of her family, in 1840, she would go to stay with the Ruskin family in London at their home in Denmark Hill and a friendship blossomed between the two. George Gray was in favour of a match when Effie had matured, and Ruskin was evidently charmed with her. When she was twelve and he twenty-one, he wrote her the fantasy story *The King of the Golden River*. In 1848, Ruskin's marriage

Effie Gray, aged eighteen. Pencil drawing by G. F. Watts RA.

to nineteen-year-old Effie took place at Bowerswell House. The marriage was not to be a happy one. The couple's conflicting personalities seemed to cause tension right from the start, beginning during their honeymoon in Venice. Nor was it a marriage that was consummated, as Effie was to later state her husband was 'disgusted with my person the first evening'.

The couple struggled on, but then Effie fell in love, not with her husband, but with the artist John Everett Millais. Ruskin had become a patron of the Pre-Raphaelite Brotherhood from 1851 and his wife sat as the model for Millais's painting *Order of Release*, which was completed in 1853. The same year, he accompanied the couple as they travelled to Glen Finglas, where he painted Ruskin's portrait. It is unknown exactly when Effie and Millais fell in love with each other or how they planned to be together, but on 25 April 1854 she left her husband and successfully sought an annulment, causing the start of the major public scandal that had repulsed the queen so much.

On 3 July 1855, Effie and Millais were married, further scandalising Victorian society. However, it would seem to be a much more fulfilling marriage for Effie, who rode out the scandal. The couple had eight children together and were together for forty years when Millais died in 1896, having also gained the title Lady Millais on her husband's elevation to the baronetage by Queen Victoria. After her husband's burial at St Pauls Cathedral, Effie returned to Perthshire. She died at Bowerswell on 23 December 1897, sixteen months after the death of her husband. She was buried beside their son George, who died aged two, in Kinnoull parish churchyard.

Memorial to Effie and her son.

The Sweetest of Women

At the west end of Caputh cemetery is the burial enclosure of the Lyles of Glendelvine. While this title might not bring forth instant recognition, the family are associated with classic green and gold tins depicting a lion surrounded by bees – Lyle's Golden Syrup.

Alexander Park Lyle was born on 2 August 1849, the son of Abraham Lyle and Mary Park. Abraham Lyle founded the sugar refiners Abram Lyle and Sons in 1887, which would later merge with the company of his rival Henry Tate to become Tate and Lyle. In 1881, Lyle and his three sons bought two wharfs in East London to construct a refinery for producing Golden Syrup. The brand is still sold today and is believed to be the oldest in Britain.

When Abraham Lyle died he left a fortune. He was buried in Greenock. This enclosure belongs to his son, Alexander, a successful businessman and well-known philanthropist who further built up the family's fortunes and reputation. It is not these great men whose attention is drawn to when visiting this enclosure, however. Grace

Above left: Tin of the famous Golden Syrup.

Above right: Grace Eleanora Moir's monument.

Eleanora Moir was the wife of Alexander Park Lyle, who he married on 30 April 1880. The loving marriage produced a son, Archibald, and a daughter, Eleanor. Mrs Lyle was known for her great generosity and caring, compassionate nature. She took a keen interest in all the families of the Glendelvine Estate, something her husband continued to do after her death in 1918, which was described in the local newspaper as 'a great blow' to him. A stained-glass window dedicated to her memory was installed in Caputh Church a year later. However, the most enduring and beautiful memorial to her is a life-size bronze statue by Ernest A. Cole. Mrs Lyle's face expresses a gentle kindness that must have been evident in life. She is accompanied by two children, a boy and a girl, which dominates the enclosure. It is a stunning piece of art that clearly shows the sweet, warm affection this lady was held in.

8

Unusual Items and Buildings

Cupmark Stones

There are a surprising number of Neolithic cup-marked stones to be found in Perthshire's graveyards. These are small disc-shaped depressions that have been carved into a rock surface up to 5,500 years ago. There are two general schools of thought about how this was achieved. The first is that they were made by a carver chipping away at the surface of the rock to make the depression and the weathering of the stone over the centuries has removed all the original 'pecks'. The other is that a ritual of moving an implement in a circular motion with the point in the centre over a period of time and by various people caused the indentations. This especially seems to be the case where the cup mark becomes quite deep with a central point. Single cup marks are not uncommon, though they are usually found in a group.

Why were they done? The simple answer is we don't know. It is a question that has occupied the minds of archaeologists and historians for years. There are various theories, but that is all they are. There is no clear evidence as to their purpose. One of

Cup-mark stone at St Brides, Blair Castle.

the generally agreed upon notions is that they are part of an ancient repetitive ritual connected to death or a type of ancient funeral process. It is difficult to assign the marks an exact date, but it is clear from sites across Scotland that cup marking was a ritual that continued into the Bronze Age, as cup-mark stones have been found in cist burials that date to the early second millennium BC. While it may be frustrating to have their purpose remain a mystery to us, it is also a comforting thought in this day and age that there is still mystery and wonder out there in this ancient land.

Diver's Helmet

At Caputh Cemetery, there is one grave marker that perhaps stands out from all the others in this burial ground. In fact, it appears to be one of a kind in the Perthshire region, which is not especially known for its deep-water diving. The stone in question is that of Chief Petty Officer David John Robertson. Along with a miniature replica of a diving helmet, his inscription tells of a sad story, dying at the age of only twenty-eight. The stone was erected by Mary Scott, his wife, who states that the Chief Petty Officer of the Royal Marines died during diving operations at Loch Fyne on 11 August 1930. A look through the records shows that his death certificate states he died on 10 August 1930 at Greenock Royal Infirmary of caisson disease and cardiac failure. The couple had been married less than two years when tragedy struck. A notice in the local paper noted that at the Temperance Hotel, Stanley, on 21 December 1928, the only son of Mr and Mrs Robertson of Taymouth Cottages was married to the youngest daughter of Mr and Mrs James Scott.

Diving helmet at Caputh.

Dwellings

While this building is not unusual to find in a burial ground due to its former use, its new lease of life may come as a surprise to some visitors. Arriving at a kirkyard, bright plant pots on the doorstep, a child's bike perhaps nearby or even garden furniture may be viewed near the entrance to the kirk. A more observant visitor may even spy curtains in the windows. The reason for this is that the Church of Scotland has sold off some of its former churches in recent years, as the dwindling numbers have forced congregations to merge. Some of these buildings have been converted into houses by their new owners. While the burial ground itself is not owned by the homeowner (except in circumstances such as Scone Palace) and is being cared for by the local authority, it is always best to be mindful of the residents' privacy and to be courteous while visiting their deceased neighbours.

Flemish Bell

Entering Kettins parish churchyard through the lychgate, even before looking at the burial ground, the church demands attention. The original church was founded in April 1249, though the church building seen today dates from 1768, with the north wing added in 1870. The cast-iron rhone, decorated with arcading and hoppers in the form of griffons, was added in 1878 during a roof repair. To the west of the building is the former birdcage-design bellcote, which was removed in 1893. The bell inside is

Gargoyle hoppers.

Flemish bell at Kettins.

decorated with a band of *fleur de lys* and includes an inscription in Flemish, recording that it was given to Maria Troon (this is not a person but rather the convent of Maria Troon in Grobendonck, near Antwerp) in 1519 by Hans Popen Ruider, a German canon maker, who presumably cast it. Kirk records state that the bell was presented to the church in 1697, where it rang out until 1893 when the new steeple was built.

Immortelles

Perthshire continues to be the most concentrated region in Scotland for the once popular Victorian/Edwardian immortelles. The name derives from the French word for 'everlasting'. Flowers have long since been the offering of remembrance given to the departed. These beautiful floral mementoes to loved ones are sadly quite scarce now, as although much hardier and longer-lasting than fresh flowers, they are less hardy against modern lawnmowers and other such damage. In Scotland, they were typically made from ceramic, porcelain, metal or indeed a combination of all three, though other countries do use beads to create their immortelles. Today the marble bases that these wreaths once stood on are seen in countless burial grounds, though their flowers, protective glass domes and wire cages are long since gone.

Above: Form of immortelle at Coupar Angus.

Right: Immortelle at Logierait.

Discarded bases.

Jougs

Presbyterian Session Courts were often the authorities of an area and dealt with low-level crimes that did not need to be sent to Edinburgh. Often, these 'crimes' were nothing more than a disagreement with a member of the kirk.

An Act of Parliament in 1593 states that prisons, stocks and jougs (described as irons in England) should be placed at every parish kirk, and not just in the main populated areas. The aim was to shame people. In theory, every idle beggar and 'wrongdoer' could be forcibly placed in penance. The good folk of the parish were reminded to behave, work hard and to live godly lives.

The most common use of punishment was the temporary imprisonment in the jougs. These were placed around the neck of the 'reprobate', padlocked in place and attached by a chain usually to the wall of the church or entrance to the grounds. The most significant part of the punishment was the humiliation, though pain and discomfort would have also been endured. It was used much in the same way as the stool of penance that the person being punished would have to sit on at the forefront of the congregation at a sermon, while the minister would often refer to the wickedness of the individual, heaping more humiliation on them.

There are a couple of fantastic examples at both Monzie Parish Church, situated on the wall of the church building, and at Abernethy, where in this instance it is on the wall of the round tower next to the entrance to the grounds.

Jougs.

Library

If asked where Scotland's first lending library was, it is likely that Edinburgh or a similar city would perhaps be the chosen guess. It certainly would not be a rural Perthshire graveyard! St Mary's Chapel at Innerpeffray was built in 1508 by Sir John Drummond, 1st Laird of Innerpeffray, replacing a much older building that had been there at least since 1342. It has been the principal burial place for the Drummonds for centuries. Around the walls of the church are the coats of arms and tombstones of various branches of the Drummonds. It is one of these Drummonds who requested in his will that a library be built to house his collection of books. David Drummond, 3rd Lord Matertie, had once been an active courtier; however, on the death of his wife, Beatrix Graham, and his young sons, he retired to Innerpeffray Chapel, spending many hours alone with his books, close to his eternally rested loved ones.

His extensive collection was first housed in a room to the west of the chapel, covering subjects such as religion, astrology, law, farming, gardening, politics, medicine, witchcraft and demonology, written in English, French and Latin. His collection included family books such as the French prayer book of his brother-in-law, James Graham, 1st Marquess of Montrose, and his wife's red velvet-bound prayer book. While the original collection dates to the sixteenth and seventeenth centuries, it has been added to over the years. Shortly before his death, he drafted a will that left 5,000 Scots merks to support a schoolmaster and care for his library. He wished to support and promote education with a desire for the library and school to benefit the community. The school set up was in operation up to 1949. His successor, Robert Hay Drummond, the Archbishop of York, raised additional funds to employ the architect Charles Freebairn to design and build the building adjacent to the chapel that the library is still housed in today.

'I have lately begun a Library', the words of David Drummond.

Innerpeffray Chapel Room.

Innerpeffray Library.

Round Tower

Abernethy round tower dates from the eleventh century in the Irish round tower architectural style and is one of only two surviving towers, the other being at Brechin, Angus. It was here that Malcolm III paid homage to William the Conqueror six years after the Battle of Hastings. The purpose of the tower has largely been debated over the centuries. The most commonly accepted theory is that it was a bell tower, as from here the handbell rung by the Culdee monks could be heard over the widest possible area. As recently as the 1800s, speculation suggested that the purpose ranged from a pre-Christian religious monument to a royal Pictish burial chamber, a notion likely supported by the addition of the Abernethy Pictish stone.

Abernethy round tower.

Yew Tree

While a yew tree is not unusual in a graveyard, one as ancient as this one is. Fortingall is situated in almost the yawning mouth of Glen Lyon. It is a quiet, picturesque village, yet it does not appear to be the location of Britain's oldest living tree. While it has been estimated to be anywhere between 3,000 and 9,000 years old, Forestry and Land Scotland considers it to be around 5,000 years old.

The tree once had a massive 16-metre-girth trunk, as it was recorded in 1769. However, it split into several different stems, giving the impression of being a series of smaller trees. The ancient heartwood's natural decaying meant the loss of the rings that could have established its true age. The wall around it was first erected in the late eighteenth century to protect it from the funeral processions that would walk between its split. The wall was replaced by a more substantial one in the early nineteenth century and which still stands today. The reason this larger wall was needed was due to the increasing fame of the tree and the increase in visitors. From this, various legends and stories seemed to sprout. One of the more outlandish claims and one dismissed by historians is that Pontius Pilate was born at Fortingall and, as a child, played below its branches.

Visitors began to request souvenirs of their visit to this ancient tree, which locals were happy to oblige. One report states that fourteen large branches were cut from the tree to make drinking cups and other such curiosities.

Fortingall yew.

Due to the longevity of yew trees, they have been associated with death and immortality. While it is easy to think of the tree growing in a burial ground, it is in fact the church and its graveyard that have come to be, many centuries after the Fortingall yew was a tiny sapling.

Watch House

Perthshire was not an area to be spared from the fear of the body snatchers, or resurrectionists as they were more commonly known at the time. Demand for fresh corpses for the anatomy schools was so high that it was not only the large cities that needed to protect their dead. These small stone buildings have windows that look out across the burial ground and generally have a small fireplace, so those who were to spend the long nights watching over the newly dead would be able to keep warm through their vigil. Here they would stay night after night until it was deemed that the bodies would no longer be of use to the surgeons and their students. The watch house at Callandar has since had its windows bricked up, but there is no doubt about its original purpose.

At Coupar Angus the octagonal watch house is situated centrally in the burial ground, giving it a good vantage point to survey the surrounding area. Interestingly, there is a building nearby that seems to be connected to the watch house. The mausoleum for the Murrays of Simprim contains a rather curious addition. Inside this unsuspecting mausoleum there is a sink and a slab that looks to be for the study for anatomy. Why would a building in a graveyard, where the dead are meant to eternally rest, have such objects? There have been some reports that state this was used as a mort house, but there are no other records of a mort house having a sink. Perhaps a budding anatomist once lived in the area?

Other watch houses can be seen at Amgask, Blackford, Caputh, Clunie, Forteviot, Kinfause, Kinnaird and Redgorton.

Suspect mort house at Coupar Angus.

Watch house at Callendar.

9

Unusual Burial Grounds

Perth Prison

While this may seem an unusual burial ground, and certainly not one most of us can visit, it is historically an important one that reminds us of the judicial past of Scotland and how crime and punishment were conducted and treated.

Perth Prison is Scotland's oldest prison that is still in use, though its first prisoners would not recognise it today. Opened in 1810 as Perth Depot, its purpose was to hold French soldiers of the Napoleonic War. It was then selected as a public prison in 1839, opening in 1842, it was also to house the criminally insane.

In July 2006, Headland Archaeology Ltd excavated the remains of a number of skeletons discovered during construction work in an exercise yard. Initially, it was thought to be a burial ground for the French prisoners of war. However, further investigation made this hypothesis unlikely.

It is believed that it's the inmates of the prison's asylum who were buried here. The expert analysis found that the twenty-four coffined bodies were all adults, aged between twenty and sixty-five years. Five were female, fourteen male, and six were unidentifiable due to the poor condition of the remains. They had been buried in an area of thick clay and the coffins had collapsed, which hindered the work. The burials had all taken place at roughly the same time, which indicated gaol fever, an epidemic of typhus, a one-time deadly disease transmitted by lice, which thrived in overcrowded places such as prisons.

There are a further four people buried within the confines of the prison, all in unmarked graves and with no confusion as to their identity; they were inmates who were executed here.

The Royal Commission on Capital Punishment recommended ending public executions in 1866. This was the result of the public execution of George Bryce in 1864. It was observed that the feelings of the gathering crowd had been running high and a terrible combination of potential lynch mob and carnival goers was displayed by those present. Since there were fewer hangings in Edinburgh, there was no longer a public executioner, so Thomas Askern from York was brought in. There are conflicting accounts of the executioner's ability, or lack thereof. It was reported that he was drunk, had lied about his qualifications or harboured malicious intent towards the prisoner. Whatever the reason, he had failed to measure the correct length to drop Bryce to a swift death. Instead, the man fell short and was slowly strangled in front of the crowd. Their former abuse towards the condemned was swiftly redirected towards the executioner and the authorities in light of the prisoner's slow suffering.

In 1870, George Chalmers was caught after his mugshot was circulated by the police. Convicted of murdering John Miller, the tollbooth keeper at Blackhill Tollbooth, he was the first person to be executed in private behind prison walls in Scotland. He was followed by Edward Johnstone (1908) for the murder of Jane Wallace, Alexander Edmundstone (1909) for the murder of sixteen-year-old Michael Swinton Brown and Stanislav Mizka (1948) for the murder of Catherine McIntyre.

Maggie Wall's Monument

Just outside the village of Dunning is a rather curious monument within a stone-walled enclosure. Atop a cairn is a cross and the white-painted words 'Maggie Wall burnt here 1657 as a witch'. There is no other monument like it in Scotland, and out of the thousands of women condemned to death, why would Maggie be singled out to be remembered? What makes this monument all the more intriguing is that there is no record of a Maggie Wall being tried or even living in the area. A few years after the date inscribed on the stone, six women were tried as witches in Dunning, and their trial was documented. It's not even as if Maggie could have been the last woman burnt as a witch in Scotland, as that unfavourable honour goes to Janet Horne of Dornoch in either 1722 or 1727 (the records on this are not clear either).

The memorial itself is just as curious and surrounded by questions without answers. Who built it? It is said to have been installed not long after the alleged burning. It must have been someone with considerable power and standing in the community, as most common folk would have been terrified of showing sympathy to someone executed as a witch. Local historian Kenny Laing believes that it was the local landowner, Lord Andrew Rollo, whose estate the monument was built on. In 1657, his son had been the local minister and would have no doubt been instrumental in the trial outcome. The cost of the monument also needs to be considered. Sitting nearly 20 feet high with cut stone, it was clearly not just 'thrown together' but carefully planned.

Another mystery is the yearly wreath left and the lettering being kept fresh. Photos of the monument a hundred years ago show the lettering in situ. The style remains exact, with the mysterious painter sticking to the original lines. Locals state that no one knows who is responsible, though speculation gives two possibilities. The first being that there is a rumour that an active coven in the area tenderly cares for the monument, keeping the memory of Maggie and the thousands of women persecuted alive in people's minds. The second is that it's the local Freemasons, who, for some unknown reason, feel it is their responsibility to maintain it. No parts of the monument appear to have been 'borrowed' for the building of walls, etc, in the prevailing centuries, which suggests there is a local level of protection. There also appears to be no outside interference from organisations such as Historic Scotland, despite a lack of an information board; however, they did establish it as a Category B listed building in 1971.

There is an assortment of offerings left at the monument that seems to have started in the last few years. A casual look around the monument reveals items of jewellery, painted rocks, pieces of paper with names upon them, letters, shells, flowers and coins.

Above left: Maggie Wall monument.

Above right: Offerings left at Maggie Wall's monument.

Suicides Graves

There is an entry in the *Ordnance Survey Name Books of Perthshire 1859–1862* that states a place that has been given the name 'Suicides Graves'. The description is given that on the summit of Corry Our, there is an area that is identified locally as having been 'the place of interment for such persons who committed suicide in the parish'. It is likely that this area stopped being used as a burial place after the Burial of Suicides Act 1823 (also known as the Right to Burial Act 1823) was granted royal assent on 8 July 1823 and passed by the Parliament of the United Kingdom. It removed the ban of the burial of suicides, or self-murder, in consecrated ground.

Today a modern forestry plantation is on the summit, apart from an area of moorland about 1.5 acres left untouched. The Forestry Commission had discovered records that indicated this area on the boundary of the parishes or Ardoch and Muthill had been used for burial and as such decided not to plant in the area.

Forgotten Burial Grounds

It is a sad fact of Perthshire's history that many people were displaced from their homes, leading to their dead becoming neglected, their once cherished burial grounds rarely visited or reclaimed by nature. While the closure of cottage industries made up a lot of these, Culloden was to have a monumental impact on this area of Scotland. For example, the people of Balquhidder, being involved in the Battle of Culloden on the doomed Jacobite side, meant the whole estate of Invercarnaige was fired and laid to waste. Houses in the Glen were burned and the great depopulation of the parish followed, mainly by emigration to Georgia and America, which remained for a time a Gaelic-speaking community. A number of the descendants of Rob Roy MacGregor emigrated to the West Indies in 1754. A significant number of emigrants from Breadalbane, Lochernhead and Balquhidder left for Nova Scotia with Gaelic ministers to follow in the early nineteenth century. Sadly, the number of these forgotten burial grounds in this region are too numerous to extensively cover, and only a few can be chosen to represent the rest.

Cladh Chunnas, Glen Lyon

This little graveyard seems a little misplaced, sitting in the middle of a field. However, it is instead the village it served, Inervar, that could be described as being misplaced. The industrial village of Inervar was employed in the production of flax which centred on an eighteenth-century lint mill. When flax became cheaper due to both the Industrial Revolution and cheap imports, the mill went out of use and the residents began to leave. The mill is a Scheduled Monument, and its description name has even been given as 'Inervar, shrunken township, Glen Lyon'. The burial ground, no longer in use, is named after St Cunna of which the name translates to 'St Cunna's Graveyard'. It is believed that there was a saint's well to the rear of the burial ground, though the exact location has also been lost and, indeed, at the time of publishing, the story of this ancient saint has also become misplaced through time.

Cladh Chunnas.

St Brides at Brig O' Turk

When driving from Kilmahog to Loch Lubnaig most people give little thought to what appears to be a single gravestone in a small rough walled enclosure as their attention is captivated by the beauty of the loch and Ben Vorlich. This is the former chapel of St Brides and the traditional burial place of the MacKinlays of Annie Farm. While there are ten recorded graves, the one gravestone that can be seen is that of John MacKinlay (1645–88). John had three sons: Donald, James 'the trooper' and John. It was his middle son, James, who went to Ireland, where the spelling of his name changed to McKinley. It is this branch of the McKinleys that the 25th President of the United States, William McKinley, descends from.

The Village of Lawers

It has been around 100 years since the last resident abandoned the village of Old Lawers, an area with centuries of history. The original church of the village was

St Brides at Brig o' Turk.

Forgotten Burial Grounds

situated in the burial ground over the Lawers Burn near to the village on the banks of Loch Tay. Most of the markers are from the eighteenth century, though there is one that may display the date of 1531. It would have probably remained a place of relative anonymity if it had not been for the Lady of Lawers, a soothsayer of the late seventeenth century. There are conflicting names associated with her. Some say she was the daughter of the Campbell Laird while others declare that she was from the Stewarts of Appin and married into the Campbells. Regardless of her name, some of her prophecies have come true. The first regards the new kirk being built in the village in 1669. The ridging stones had been brought from Kenmore by boat and left on the shore. She predicted, however, that they would never make up the fabric of the new church. That night a great storm blew up, battering the shores of the loch and the ridging stones were washed into the depths of the water, where they were to remain.

Her other prophecies would include 'fire-coaches yet to be seen crossing the Drumochter Pass'. Almost 200 years later was the introduction of steam trains along the Highland Railway. A few of her prophecies were connected to an ash tree that she had planted next to the new kirk. She stated that when the tree reached the height of

The old village of Lawers Graveyard.

the gable, the church would be 'rent in twain'. The Great Disruption of 1843 saw the congregation leave the Church of Scotland and join the Free Church. She had further noted that when the tree reached the ridge of the roof, the House of Balloch would be left without an heir. In 1862, the furthest most tip reached the ridge, the same year the Marquis of Breadalbane died without an heir. The most ominous is that whoever should cut down the tree will come to an evil end. In the late nineteenth century two men from nearby Milton farm removed part of the tree. One soon after lost his sanity and was placed in an asylum; the other, John Campbell, was killed by one of his own bulls.

The church at Old Lawers.

11

Some of the Best Burial Grounds

It is near impossible to pick some of the standout burial grounds in Perthshire, as each and every one of them deserves to be studied and visited. However, if there were five that should not be missed, then these are the ones to visit.

Coupar Angus Abbey Churchyard

The abbey churchyard of Coupar Angus offers only subtle clues to its illustrious past. The only real visible clue to the grand building that once stood here is the ruinous gatehouse of the abbey. Now a Scheduled Monument, the Moray Estate still owns it. Early sketches indicate that this has been all that has remained since the late eighteenth century. It is not the first building of note here, as a sizable Roman camp occupied the land before that.

The abbey's gatehouse.

Coupar Angus Abbey Church.

The abbey was established under the orders of Malcolm IV in 1164 and was controlled by the parent House at Cîteaux, France, and was of the Cistercian order. The monks were identifiable by their white robes. The church of Copra Abbey was dedicated on Ascension Day, 15 May 1223. While the number of monks never exceeded twenty at any one time, it became one of Scotland's wealthiest abbeys, significantly helped by royal favour.

Malcolm IV endowed the abbey with lands.
William the Lion granted more lands and excluded the monks from all tolls, market fees and all custom dues.
Alexander II gave property for sustenance in the perpetuity of two monks. They were to say Mass in the Chapel of the Holy Trinity at the Loch of Forfar. He also provided lighting at the monastery.
Robert the Bruce granted a charter that allowed the monks to fish for salmon in the Tay at times when all others were prohibited by law.

History is reasonably quiet about the decline of the abbey. Many of the neighbouring buildings are built from the distinctive red sandstone of this once-great building. It was noted that by the time of the Reformation the building was in a state of poor repair; therefore, a Reforming mob would have required little effort to tear it down.

Remains of the abbey.

Graveyard watch house with its distinctive red stone.

There is a mystery connected to the grounds with a secret tunnel and a disappearance in the nineteenth century. Though some tales recall it was a group of women and others some workmen, the story remains the same. To simplify, a group of people found the entrance to the Ley Tunnel of Coupar Angus Abbey near the entrance to the churchyard. One of the party was brave/foolish enough to explore the tunnel solo while the others held back. The hours passed and their companion never came back (and apparently, no one followed or searched!). In 1982, a local man discovered the entrance once more and went in. He was able to go some distance until he found a cave-in and it was surmised that this was the explanation for the previous century's disappearance.

Dunkeld Cathedral

Dunkeld Cathedral is one of the most significant religious buildings in Scotland and arguably in the most beautiful church setting. Situated on the banks of the River Tay, construction began in the mid-thirteenth century on the site of an early Celtic Church building, with worship here dating back to the sixth century. While the Reformation caused significant damage to the building, the choir was restored and is still in use today as the parish church. The array of monuments from different centuries to be found inside makes this an absolute must-visit location for its stunning examples of funerary art.

Dunkeld Cathedral.

The most striking effigy is that of the Royal Prince Alexander Stewart, Earl of Buchan, or as he is better known the Wolf of Badenoch. His somewhat defaced monument, carved from Glen Tilt marble, is still rather magnificent in its size and detail. While the recumbent figure in full armour, a lion at his feet, commands attention, the sarcophagus sides contain twenty-two knights, each in a differing pose. Its Latin inscription reads: 'His Jacet Domninus Alexander Senescallus, Dominus De Badenoch, Bonæ Memorle, Qui Obit 24 Die Mensis Julii, Anno Domini 1394'.

It remains one of the few Scottish royal monuments to have survived the Reformation. The fact that it survives at all is perhaps the biggest mystery, considering the contempt he has been held in over the centuries since his death, and the terror he instilled in the years before.

The history books have been far from complimentary about this man, though they are not unjustified due to his own actions. Even the stories that circle around his demise would not surprise any who would casually look at the deeds during his life. Born the third son of Scotland's first Stewart king, Robert II, he was legitimised when his parents married. The king, having a number of sons when he came to the throne, knew that each needed to be provided for and as such gave them lands and titles. Alexander was bestowed the lordships of Badenoch and Lochindorb. He was also appointed as the justiciar in northern Scotland, which gave him full authority of the Scottish crown. He was to extend his lands through marriage to the widowed Euphemia de Ross. The only child of the Earl of Ross, who had inherited the lands stripped from her father, making her the Countess of Ross. Widowed around the age

The Wolf of Badenoch.

of thirty-five, she married Alexander Stewart, upon which they were created the Earl and Countess of Buchan. He now had a huge swathe of land stretching from the Cromarty Firth to Torridon. Not long after their marriage, she discovered her husband already had a long-term woman in his life: the low-born Mariota Athyn, with whom he had numerous children. The marriage was to be doomed from the start. Although the countess had two children from her first marriage, she and Alexander were never able to conceive, and this was something he blamed her for.

As well as effectively imprisoning his wife, he held her relatives in relative contempt, accused on numerous occasions of sending his men to raid the counties and extort protection money. Those who opposed him were simply locked up or murdered and while Robert II was in power, Alexander was virtually untouchable. Seven years after his marriage he sought to rid himself of his wife while trying to keep her lands. He enlisted the help of Bishop Alexander Bur, the Bishop of Moray, but rather than side with him, he favoured Euphemia. When Alexander cast her aside in favour of his long-term mistress, Moray excommunicated him.

This provoked a spectacular act of anger and revenge that far exceeded what would be deemed justified. In May 1390, at the head of a band of 'wyld wykkyd Heland-men' he sacked the town of Forres. His attentions then turned to Pluscarden Abbey on his way to his final target in Elgin. Arriving on 17 June he completely decimated the town and laid waste to the seat of Bishop Moray, 'the Lantern in the North', Elgin Cathedral. It was this action above all others that earned him the name the Wolf of Badenoch.

His brother, still to be crowned Robert III, called upon him to do penance for his crimes and to pay in part for the destruction. This done and no doubt in a less than sincere manner, he was pardoned of his crimes.

The Wolf of Badenoch's death is depicted as 24 July 1394 on his tomb, but this has been debated by historians, as has the manner of which he died. The most popular tale of his demise, however, is perhaps the most fitting. It is said that a tall, imposing, dark-cloaked stranger arrived at Ruthven Castle, challenging the Wolf to a game of chess. The two were closeted away in the great hall while a ferocious storm battered the castle walls. Lightning tore across the sky with great peals of thunder shaking the walls. All of a sudden the storm subsided and the Wolf of Badenoch was found alone in the hall, not a mark on his body, but the soles of his boots blackened as if touched by the fires of hell. This was the demise of the man who played his final game of chess with the Devil and lost.

On the wall behind, in stark contrast, is the breathtakingly beautiful but sad 42nd Royal Highlanders, Black Watch monument, carved in white marble by the celebrated sculptor John Steele. It commemorates the soldiers, officers and non-commissioned officers who fell in war from the creation of the regiment in 1739 up to 1859. Inscribed upon its lower panel are the beautifully descriptive words that explain its purpose.

HERE 'MONG THE HILLS THAT NURSED EACH HARDY GAEL OUR NATIVE MARBLE/ TELLS THE SOLDIERS TALE/ ART'S MAGIC POWER EACH PERISHED FRIEND RECALLS AND HEROES HAUNT THESE OLD CATHEDRAL WALLS/ ERECTED BY THE OFFICERS OF THE CORPS 1872/ FONTENOY FLANDERS TICONDEROGA MARTINIQUE GUADELOUPE HAVANNAH EGYPT CORUNNA FUENTES D'ONOR PYRENEES NIVELLE NIVE ORTHES TOULOUSE PENINSULA WATERLOO ALMA SEVASTOPOL LUCKNOW

Black Watch Memorial, Dunkeld Cathedral.

Heartbreaking detail on the Black Watch Memorial.

Moving through into the chapter house is where the cathedral's museum is housed, where a number of monuments can be viewed. The most commanding is that of John Stewart, 1st Marquis of Atholl. He held many high offices during the reigns of both Charles II and James VII, dedicating much of his career to the crown until he was 'worn out in the service of his country'. Not only did he dedicate the last fourteen years of his life to administering justice to his people, but he also found time to marry. Lady Amelia, daughter of the Duke of Tremoville in France, died just a few weeks apart from her husband. They are interred together in the Atholl vault below the chapter house. The stunning monument not only carries their portraits but also displays the coats of arms of their family's respected, impressive connections.

In the opposite corner is the rather more humble gravestone of weaver-turned-musician Neil Gow. This self-taught fiddler gained much acclaim as a composer and teacher of Scottish reels, strathspeys and laments. At the age of eighteen, his unique style gained him fame and attracted the attention of the Duke of Atholl, who became his patron. His career path was set as he turned his back on weaving to become a full-time musician, playing many times at Blair Castle, where his portrait and fiddle can still be seen today. He has been credited with composing or adapting over eighty pieces of music that range from lively jigs to soulful laments. Dying in 1807 at Inver, he was buried at Little Dunkeld. His stone was moved inside the church for safekeeping before moving once more to Dunkeld, where it is today. It is his smiling face that greets visitors to the area from the green situated before the bridge over the Tay to Dunkeld.

1st Marquess of Atholl's monument.

The gravestone of Neil Gow.

Neil Gow's statue.

Logierait

While the church building today dates from 1806, this has been a Christian religious site since it was said that St Cedd established a church here in AD 650 while travelling from Iona to Lindisfarne. The burial ground has a number of iconic stones from various eras. The oldest is a beautiful picture stone dating for around the early eighth century, which, although is weathered, still carries a story. Is a Pictish stone of Class II category known as Logierate 1. It is set into a cobblestone surrounding and at first glance may not seem impressive as the sun does not hit it the right way. On the south-east face is a deeply carved cross, while on the other side is a pair of Pictish symbols – a horseman carrying a spear, though it is mainly his horse that is visible. Below, a serpent is seen wrapped around a rod or arrow.

The next spectacular sight to greet visitors are perhaps Scotland's most interesting mort safes that are still in existence. Here they quietly sit near some of those who still rest beneath the turf, thanks to them. There are two adult-sized mort safes that vary in length, while the smaller one was evidently designed for children's coffins. While the casual visitor may cast their eyes over these metal cages, their importance to the Presbyterian members of the parish was immense. Presbyterians believed that the body was needed for the Day of Judgement when the Angels of the Resurrection would blow their horns and, as such, could not be corrupted or interfered with in any way and especially not cut up by the surgeon's knife. They would have been hired by the family of the deceased to fit around the coffin until the body was no longer useful to the surgeons.

Logierait 1 Pictish stone.

Mortsafes in three sizes.

These mort safes, it has been said, inspired Robert Louis Stevenson to write *The Body Snatchers* while staying at Kinnaird Cottage in nearby Pitlochry. In the tale, two friends are employed to find bodies for the medical school. One apparently turns to murder and, after a series of events, they turn to the rural countryside to find a new corpse, only to find the body of the man previously murdered and disposed of. It was perhaps curious to Stevenson to find that the rural countryside would need to protect its dead and it was not a problem confined to the big cities. Scottish newspapers of the era did not report on the goings-on inside the graveyards of Scotland, where bodies were being taken for the medical school's tables. This is frustrating for historians, as we will never really know the extent of the problem. Was there really a dire need for mort safes in the rural areas, where the transporting of unsavoury cargo would be difficult or were small communities scare mongered into protecting their dead by those who would financially benefit from providing a service of protection? It is known and reported on in English newspapers that corpses were shipped to Edinburgh from places like London and Liverpool for the Edinburgh medical school, though those locations were not small, close-knit communities where strangers would instantly be identified, nor in a landlocked region did they have the benefit of the sea for transportation. It would have been a massive risk for anyone considering such a trade. However, to the people of this parish, they were evidently needed and serves as a reminder of the era that brought such medical advancement that still benefits us today.

There are a series of Adam and Eve stones and Abraham and Isaac stones which are of a particularly fine quality. Nowhere else in Scotland has such a concentration of symbolic stones of this nature in one burial ground.

Adam and Eve at Logierait.

Abraham and Isaac at Logierait.

The kirkyard here would have also been used as the primary burial ground for the destitute and infirm who had to take refuge in the local poorhouse, a short walk along the road. Logierait Poor House, which became known as the Atholl, Weem and Breadalbane Poorhouse was opened in 1864. It provided shelter, food, and medical assistance for the old, sick, infirm, and destitute, along with those who had additional physical or mental needs. Orphaned children were temporarily housed here before they were fostered out. Additionally, there was also assistance given to single women, widows with children and pregnant women. An Act of Parliament in 1845 for the Scottish Poor Law Amendment Act stated that each parish in Scotland established a parochial board, which was encouraged to build a poor house. Smaller parishes could form unions to share costs and so larger properties than expected by modern eyes were established, with some covering up to eleven parishes. The poor house at Logierait was built to accommodate 110 inmates, but apparently was underused, generally only housing between forty and fifty people at a time.

Meigle

At first glance at the late nineteenth-century church it is hard to believe just how ancient this site is. Situated near the boundary of Perthshire and Angus, it is now somewhere people generally pass through rather than the focus of travel. This is, in fact, a place steeped with ancient Pictish mysteries and legends. The graveyard holds so many fascinating stones and markings from the eighteenth century that, the Pictish connections aside, visitors are rewarded with a rich glimpse into the area's past.

Meigle Parish Church with Vanora's Mound to the right.

Resurrection scene at Meigle.

The Arthurian legend associated here actually centres on Queen Guinevere, or Vanora as she is known locally. Vanora's Mound is regarded as the tomb of King Arthur's wife, either as a new cairn or as a reused prehistoric one. The story goes that Arthur, a sixth-century warlord of Strathclyde, went to battle with the invading Romans, leaving his nephew Mordrid in charge of his territories. The Pictish Mordrid saw this as an opportunity to seize the lands and seduce his aunt. The tales are unclear if this had been a plot they formed together or if Venora came to love Mordrid. Regardless of the how, they ruled the lands together. Arthur returned and, furious at what had occurred, went to battle with Mordrid. Victorious, he killed his nephew but sustained mortal wounds, dying soon after. With his death, Venora lost all hope of any forgiveness. For her crime, she was sentenced to death in one of the most horrific ways imaginable: torn apart by a savage pack of wild dogs. This is not the sort of tale told by the later romantics who turned the Celtic Arthurian tales into ones of chivalry and honour.

Inside the Meigle Sculptured Stone Museum, located in the former schoolhouse that backs onto the graveyard, is one of the most significant collections of Christian Pictish stones. Most of the stones were found in the graveyard, and one, Meigle 2, is believed by some to depict the killing of Vanora, though other sources claim it to be Daniel and the lions. This 2.5-metre-high, elaborately carved stone dates from ninth century. It is clear to see why the legend would fit with the scene depicted, especially as it is known locally as Venora's Stone and was part of a collection of stones located on the mound.

Meigle 2, locally known as 'Vanora's Stone'.

St Cuthbert's Kirk of Old Weem – Menzies Mausoleum

St Cuthbert's Kirk of old Weem was originally built in the late fifteenth century on the site of much earlier religious buildings. It was altered by Alexander Menzies in 1609 for the reformed religion. The altar and chancel screen were removed, the pulpit was made more central, and the entire north wall was removed, incorporating a separate room and nave to create the laird's loft with a small retiring room to the rear, of which the bricked-up fireplace can still be seen. The building continued to be the parish Kirk until 1839 when Neil Menzies, 6th Baronet, was given the right to exclusively use it as a family mausoleum, as would all his successors in all time coming.

The Menzies monument, however, well predates this exclusive use. Its most eye-catching feature inside what is already a mesmerising interior is the monument of Alexander Menzies. What really makes this mural monument even more interesting is the tribute it pays to the woman important to Sir Alexander Menzies down his maternal line. Dated 1616, it was created after the deaths of his first two wives. It has been described as an important historical monument, not just for its unusual geological record in stone but also as an important example of Scottish Renaissance work. The back panel of the recessed arch translates to:

> My mother is of the royal stock of the Britons of Atholl,
> AndLawers is the House of my grandmother.
> My great-grandmother is a fair daughter of Huntley
> And my great great-great-grandmother is from Edzell Sprung

Menzies Mausoleum.

> To the shade, and memory of the famous and noble hero Alexander Menzies of Weem and the memory of Campbell, his wife, both of whom, for the sake of all the good name of their ancestors and their prosperity, undertook the building of this monument.

Surrounding this main panel above the decorative sarcophagus are a series of tablets bearing memorial inscriptions for the woman mentioned, along with their carvings of their family heraldry. They are:

Margaret Campbell, daughter of Lord Glenorchy, wife of the Lord of Weem, died 23 September 1598.

Elizabeth Forrester, daughter of Lord Carden, second wife of the Lord of Weem, died 10 November 1603.

Barbara Stewart, daughter of Earl of Atholl, wife of James Menzies, mother of the founder of this sepulchre. Died 29 April 1587.

Christina Gordon Countess Huntley, wife of Robert Menzies of Weem, soldier, great-great-grandmother of said founder.

Margaret Lindsey, daughter of Lord Edzel, wife of Robert Menzies of Weem, soldier, great-great-grandmother of said founder.

The symbols of mortality aside (which are exquisite, especially the central dial, with Death's head, coffins, crossed bones, hourglass, sexton's tools, deid bells and death's weapons all tied up together with a ribbon), the carvings still have so much more of a

The Menzies monument.

story to tell. On either side of the panel are two life-sized figures. They are Faith and Charity. Under Faith is carved the year 1616, while under Charity is the date 'Jan 24'. There are further inscriptions:

GLORIA DEO PAX HOMINBVS – Glory to God Peace to men.
TRIVNI DEO GLORIA – Glory to the triune God. Triune is often used to mean three in one, as in the Holy Trinity.

Alexander uses the monument to also commemorate himself and his third wife, Marjory Campbell. It has been described as an 'unabashed celebration of illustrious lineage, though not oblivious of human mortality and the promise of redemption. The couple can be seen as kneeling figures at the top above two Angels of the Resurrection.

Carolyne Elizabeth Menzies.

At its centre, above all else, is a relief of God, the Father. The addition of this carving is a mystery as to why it is included, due to the banning of idolatry of effigies in the Reformed religion.

The monument to the left is one that invokes a deep sympathy for life ended far too soon and conveys the family's deep grief at the loss of a daughter. The beautifully sculpted white marble effigy is of Carolyne Elizabeth Menzies, here forever immortalised at the age of fifteen. Dying in 1845, her funerary hatchment has also survived the test of time. There are relatively few hatchments to be found in Scotland, so this and the others in the building are really quite special. Caroline's shows the typical lozenge-shaped frame on a sable background. It contains a lady's lozenge-shaped shield with the Menzies arms. It is ribboned and knotted to indicate she was unmarried. Below is her father's baronial badge. Surviving and still pinned to the black cloth frame are paper tears and skulls. Traditionally, they were forbidden in seventeenth-century Scotland (hence the rarity), though they did make a revival. They were hung on the deceased's home before being moved to the family burial chapel. Such hatchments were generally restricted to the nobility of the land.

Two of the Dull crosses can also be found here inside the mausoleum. Originally, there were four sanctuary crosses at Dull, placed around the monastery there, which was at one time the ecclesiastical centre of education in Scotland. Within the boundary

Above left: One of the Dull crosses at Weem with Carolyne's hatchment in the background.

Above right: The Dull cross in situ.

of these crosses, anyone who needed it would have safe refuge. This was also true of any consecrated church which had the right of baptism, burial and the privilege of sanctuary.

One still stands at Dull, one was lost, and the two at Weem were acquired by the Commissioner of the Menzie's estate, who thought they would make perfect gateposts for his garden. Despite dire warnings from locals, he went ahead damaging them to install a gate and subsequently came to a violent end. The two crosses were relocated to the Menzies mausoleum to keep them safe, while the third was installed as the Dull Mercat Cross. Unfortunately, it too suffered some damage when a runaway horse and cart broke off an arm during the fair dedicated to St Adamnan.

To gain access to the mausoleum, a key needs to be obtained from the nearby sixteenth-century Menzies Castle, the seat of the Clan Menzies. This Z-plan, fascinating castle is also worth visiting to learn its turbulent role in the history of the Highlands and of its illustrious family.

Castle Menzies.

Select Bibliography

Beauchamp, Elizabeth, *The Braes O' Balquhidder* (Whittles Publishing Services: Latheronwheel, 1993)
Gifford, John, *The Buildings of Scotland: Perth and Kinross* (Yale University Press: London, 2007)
Goldie, F., *A Short History of the Episcopal Church in Scotland* (SPCK: London, 1951)
Golledge, Charlotte, *Graveyards and Cemeteries of Fife* (Amberley Publishing: Stroud, 2022)
Holder, Geoff, *The Guide to Mysterious Perth* (The History Press: Stroud, 2010)
Herren, Michael and Brown, Shirley Ann, *Christ in Celtic Christianity* (The Boydell Press: Woolbridge, 2002)
James, William, *The Order of Release* (John Murray: London, 1947)
Love, Dane, *Scottish Kirkyards* (Amberley Publishing, Stroud, 2010)
McHardy, Stuart, *The Well of the Heads: Historical Tales of the Scottish Clans*
McKerracher, Archie, *Perthshire in History and Legend* (John Donald Publishers Ltd: Edinburgh, 2002)
Steven, Maisie, *Parish Life in Eighteenth Century Scotland* (Scottish Cultural Press: Dalkeith, 2002)
Tranter, Nigel, *The Queen's Scotland: The Heartland* (Holder and Stoughton: London, 1971)